PAUL KOH

catmaSutra

A COLOURING ADVENTURE

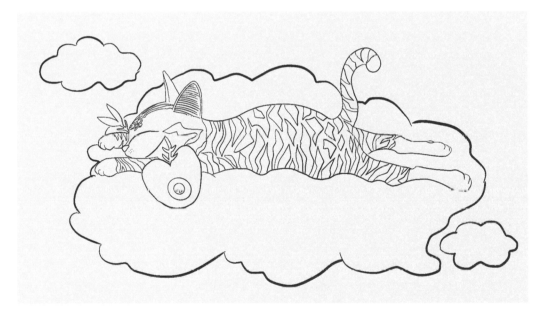

Marshall Cavendish
Editions

The Muse

The term catmaSutra was coined to capture the seemingly zen-like essence of cats in different positions and situations (real-life and make-believe). The artist then draws us into a space where the playful and good-natured juxtapose with the tongue-in-cheek and unexpected…all distilled on canvas to create the catmaSutra cat, distinguished by its trademark 'eyes-wide-shut' and 'ear-to-ear' grin. Synthesizing elements from his keen observations on life and experiences, combined with his personal brand of positive karmic energy, Paul has created an extraordinary place where our reality becomes cat – simpler and free-spirited – quaintness.

Paul was also invited to participate in the Elephant Parade Singapore, in an effort to raise awareness of the conservation and protection of Asian elephants. Paul's The Elephant and the Cat was displayed at VivoCity and successfully auctioned off by Sotheby's.

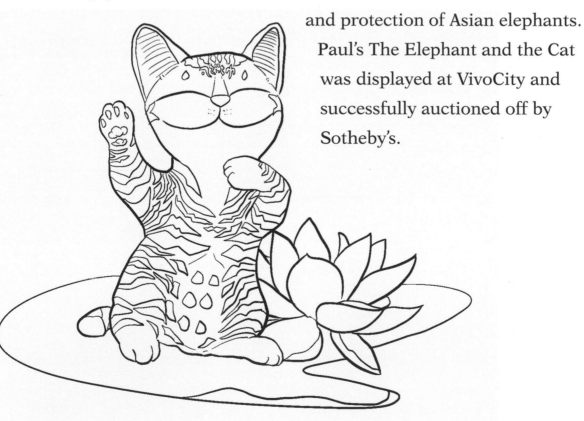

About the Illustrator

Singaporean artist, Paul Koh, has over the
decade, built up a collection of paintings
inspired by the real-life personalities,
eccentricities and adventures of his two pets,
Halo, a ginger tabby and Angel, a Russian Blue.
Through his paintings, Paul has captured the
affectionate inquisitiveness and nonchalant
independence typical of the feline.

With 16 solo and several group exhibitions since 2004 under his
belt, Paul has developed a consistent following over the years.
Collectors are enthralled with his eclectic collection of paintings
exuding an appeal that attracts both art and animal lovers alike.

Upon graduation from Simon Fraser University (Canada),
Paul spent 20 years in the creative and communications field,
specialising in content and design management. Paul's multi-
disciplinary experience spans design, literary arts, visual arts
as well as interactive media.

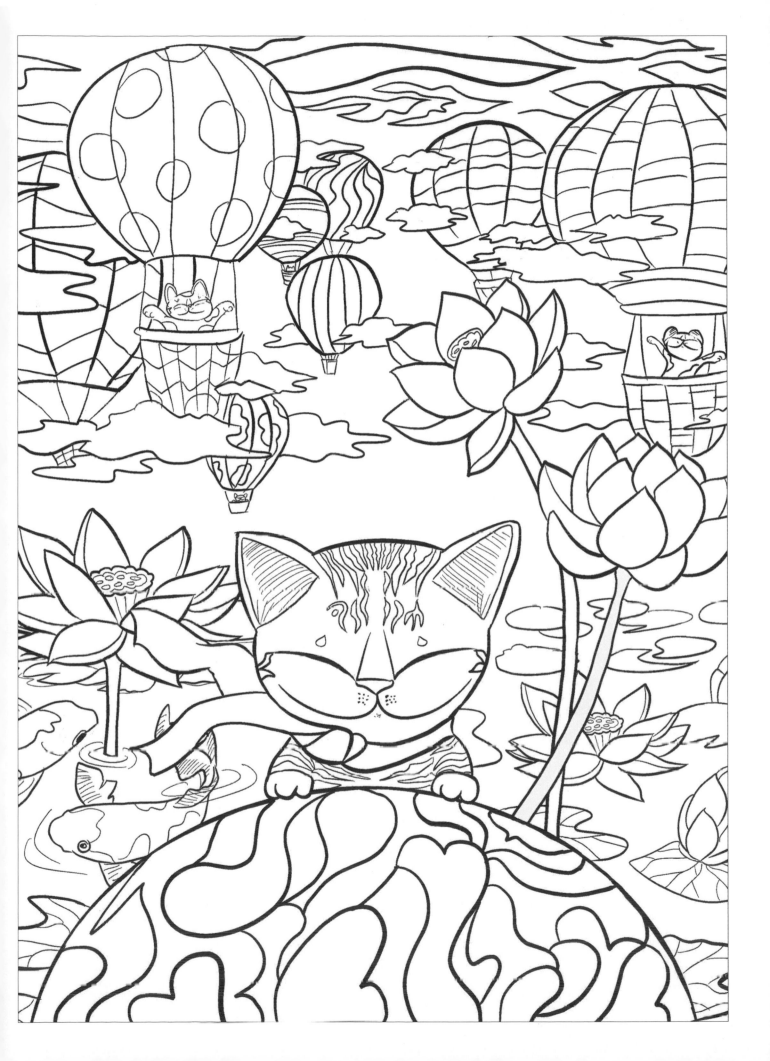

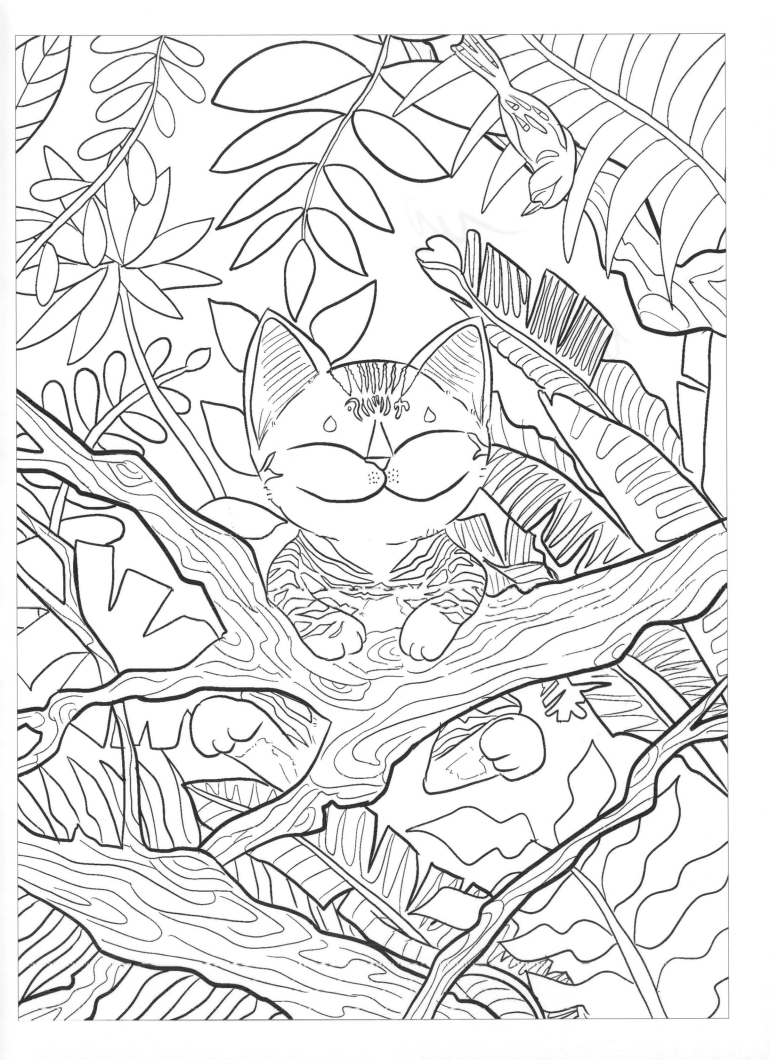

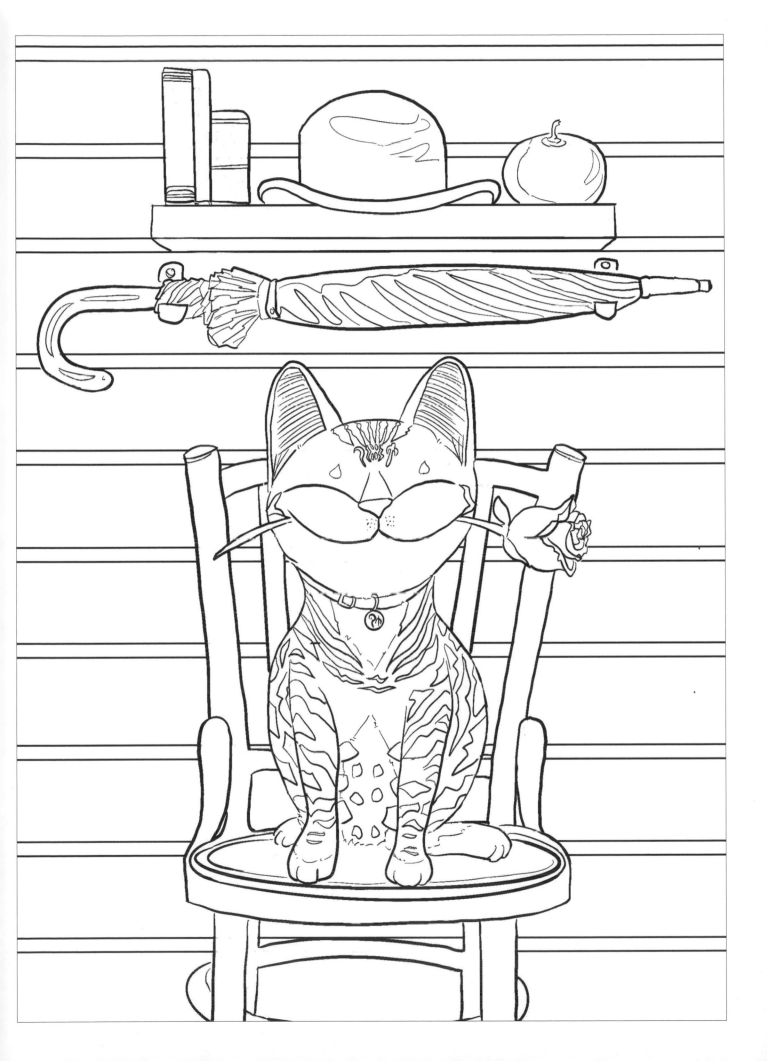

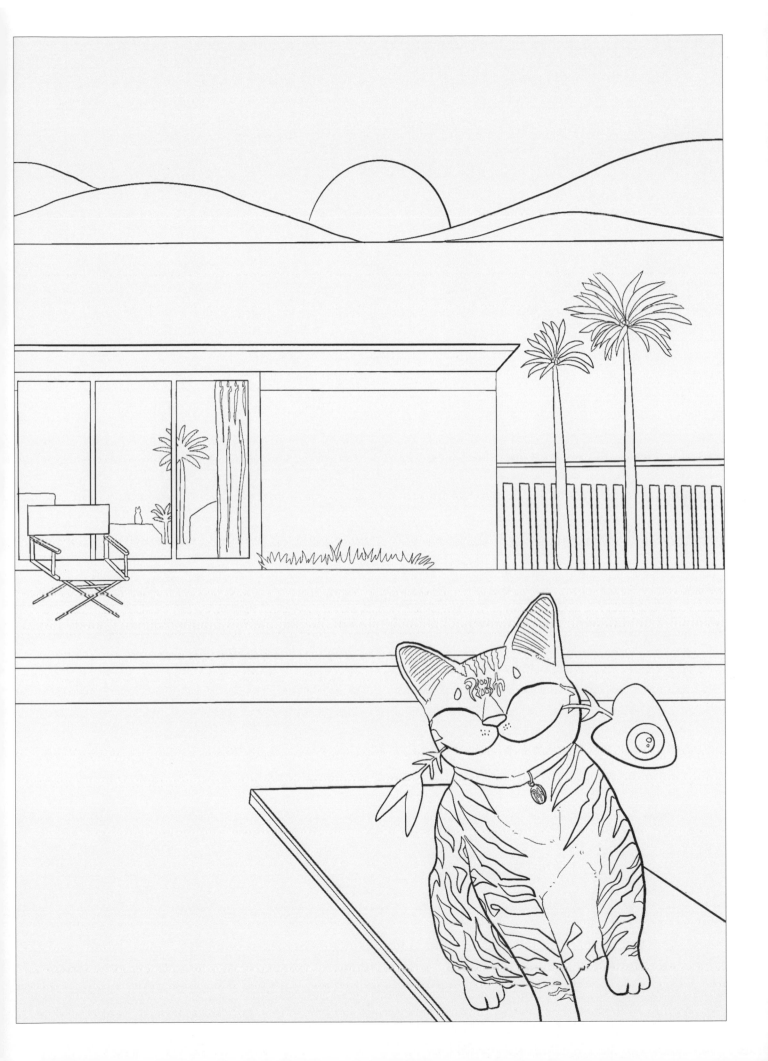

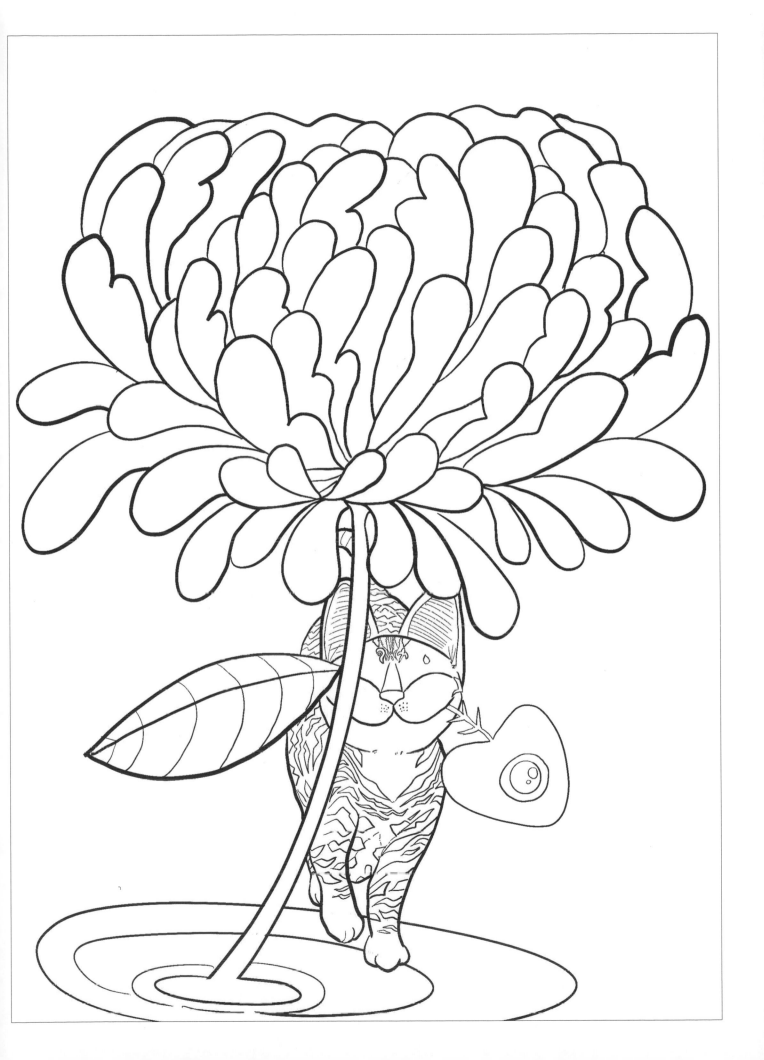

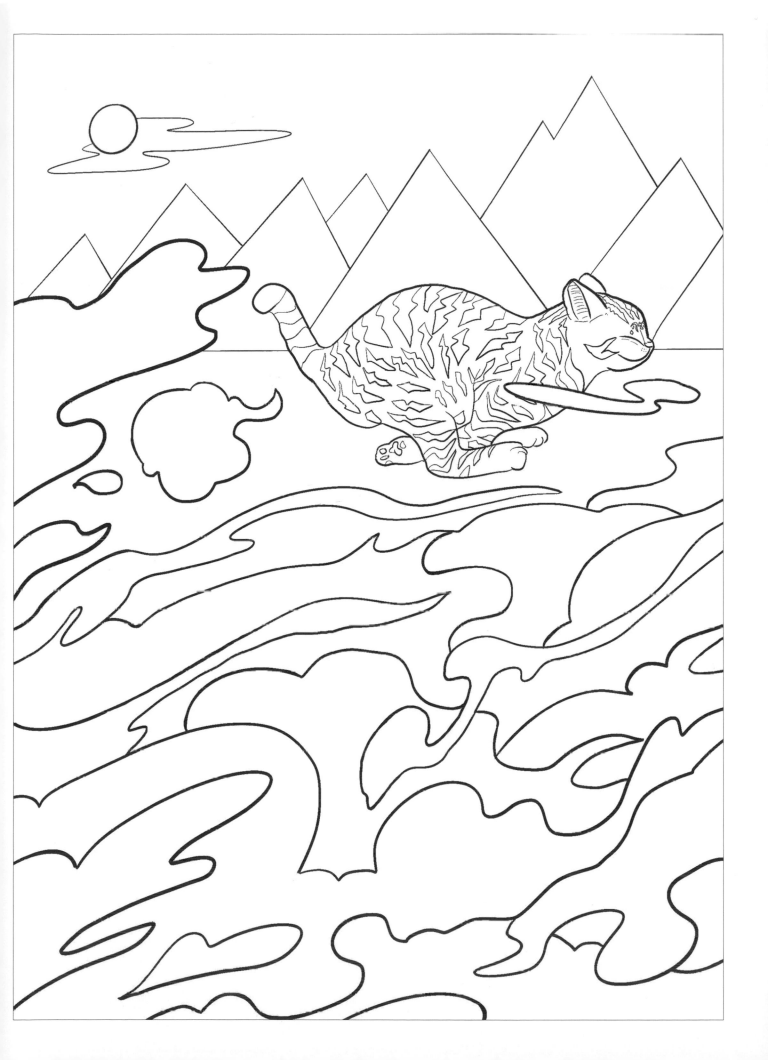

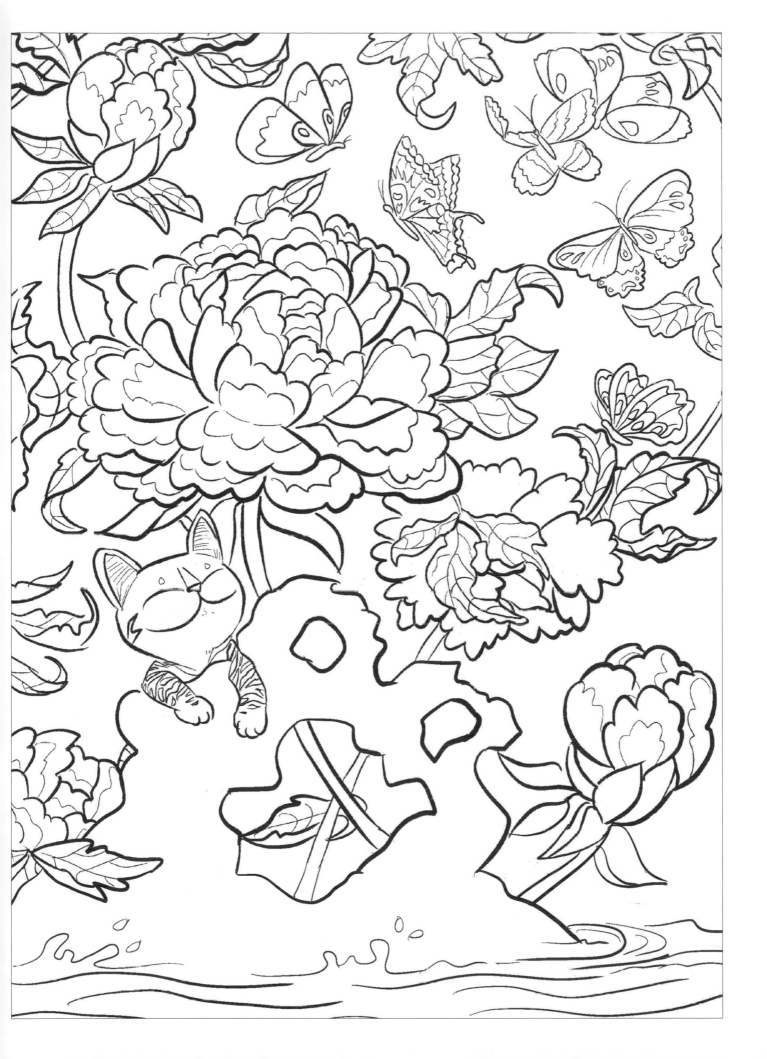

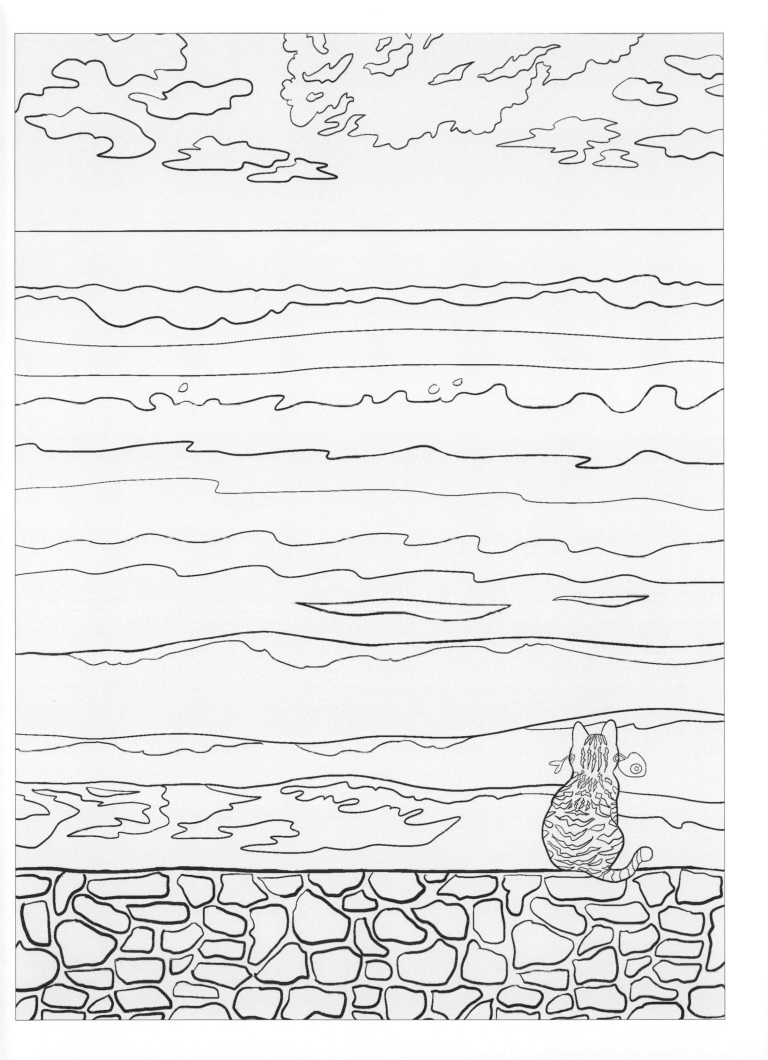

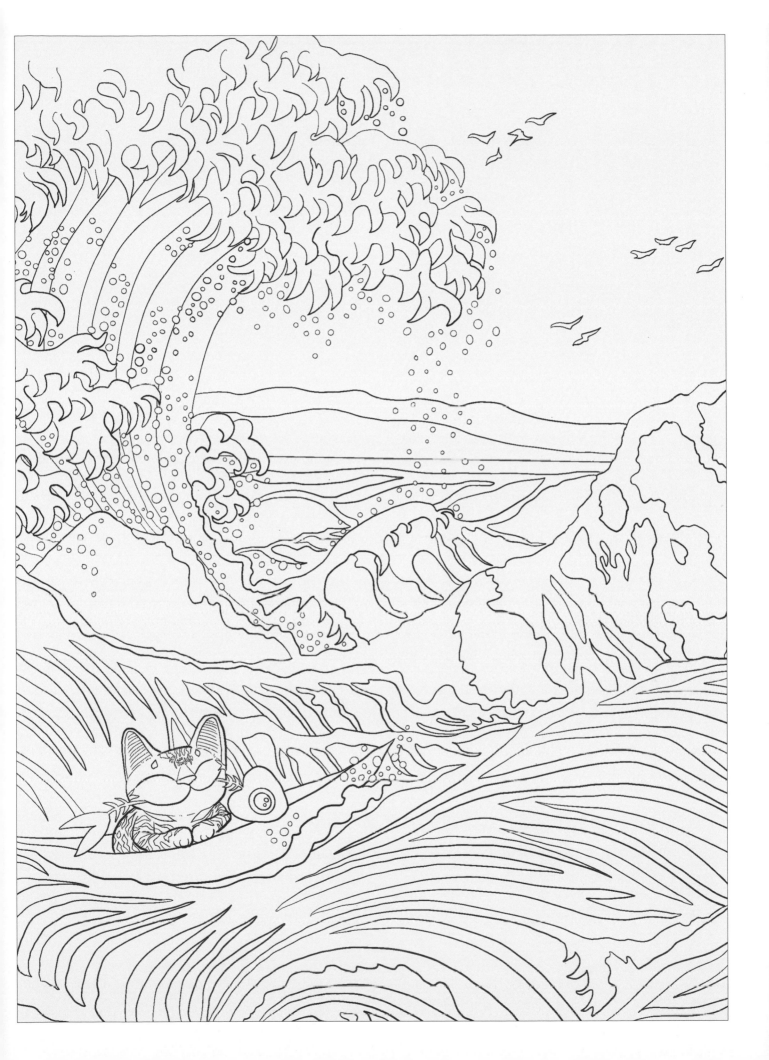

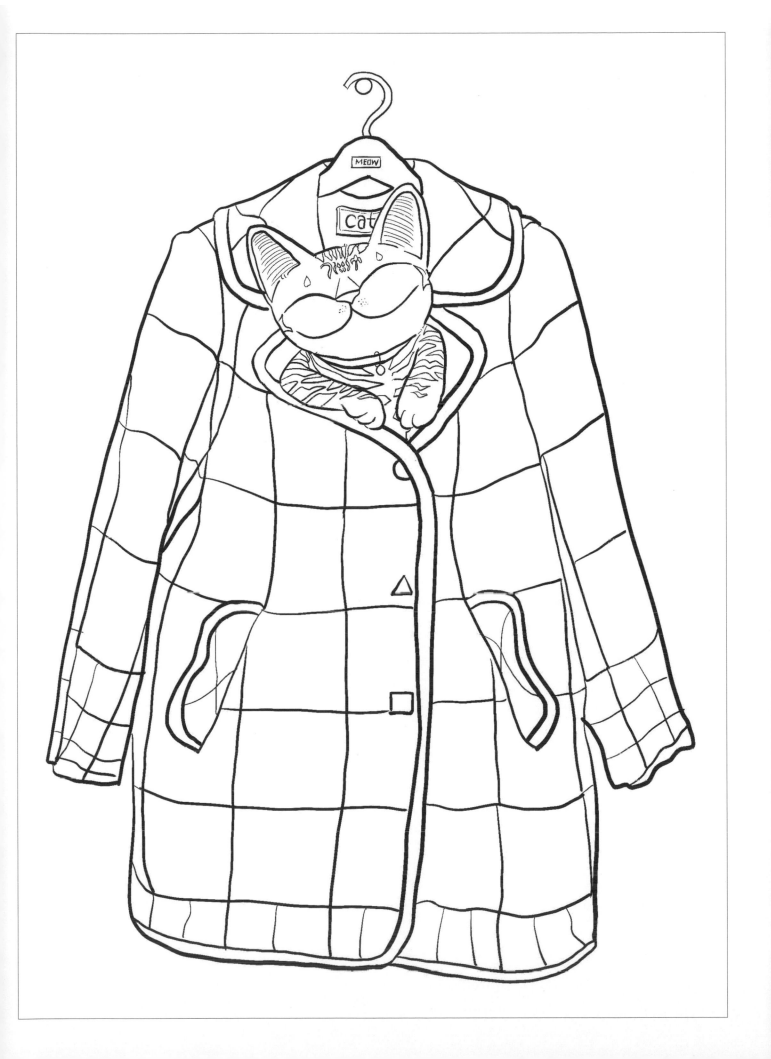

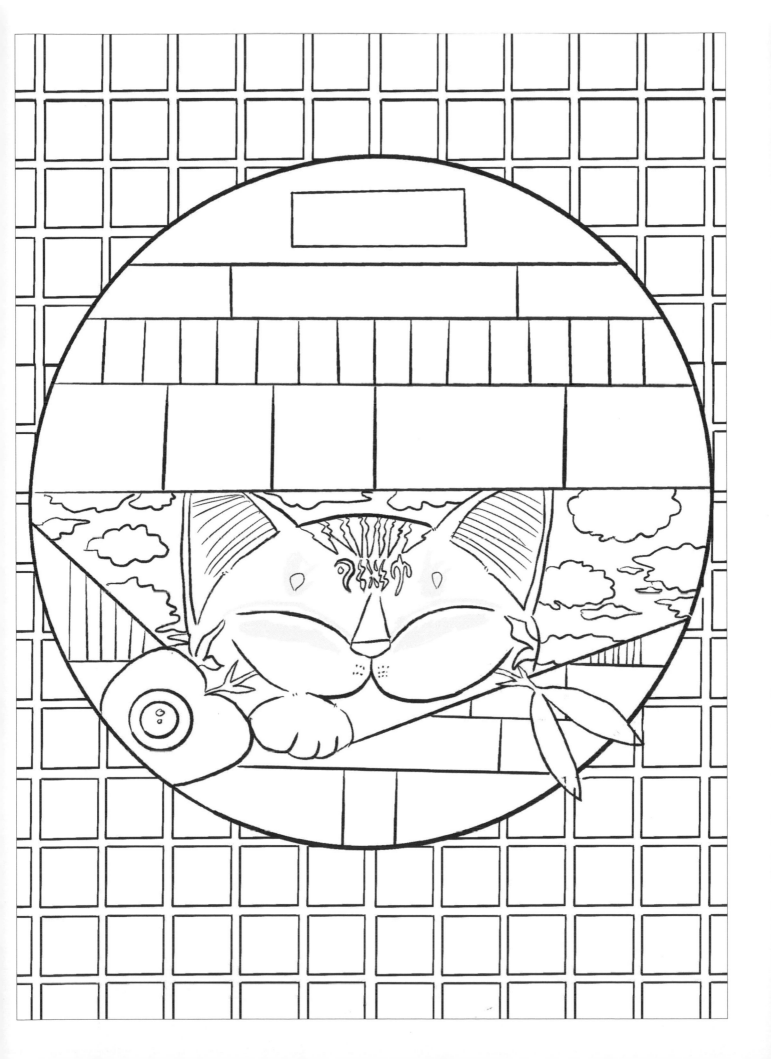

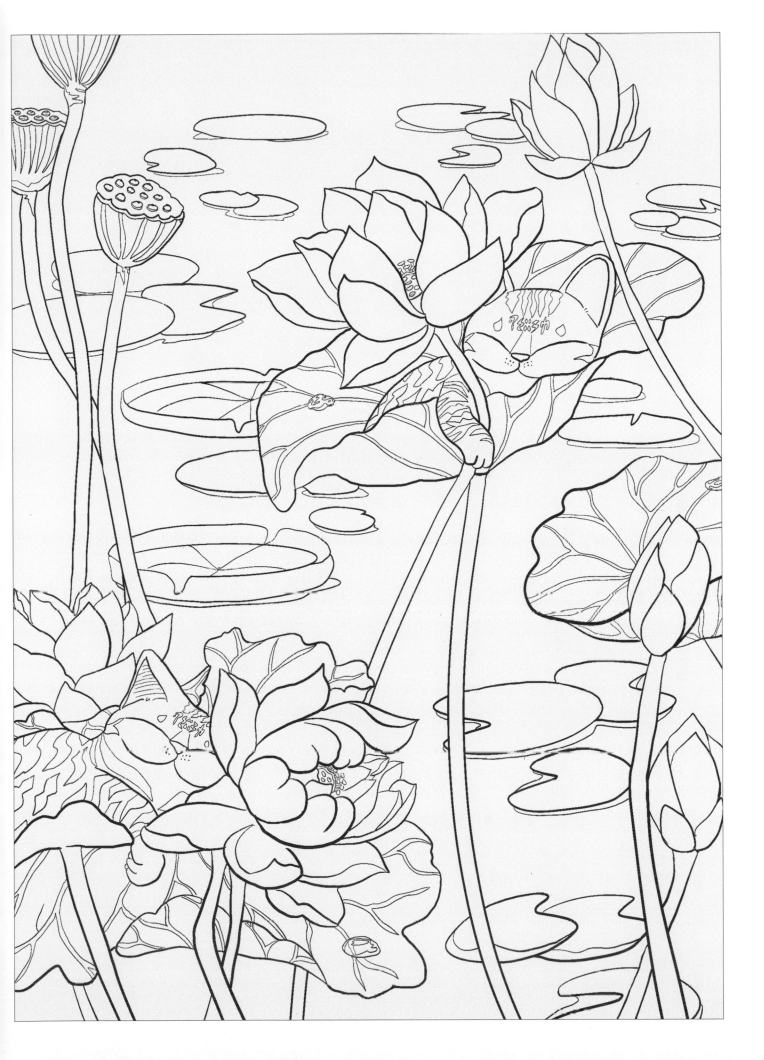

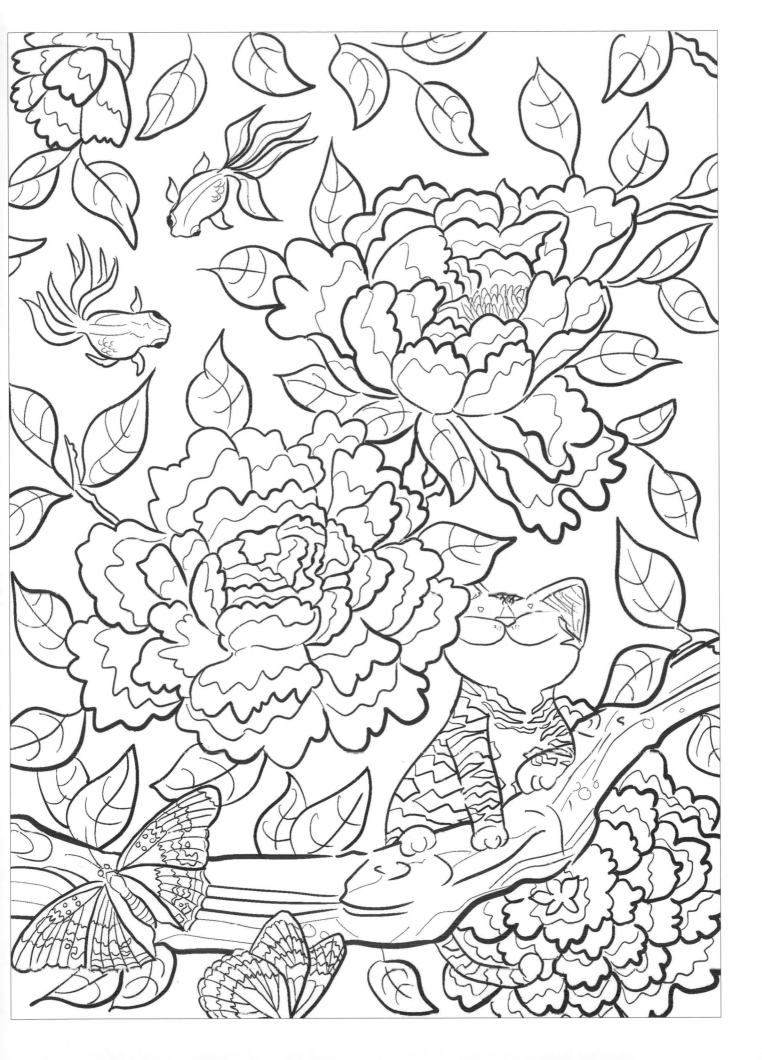

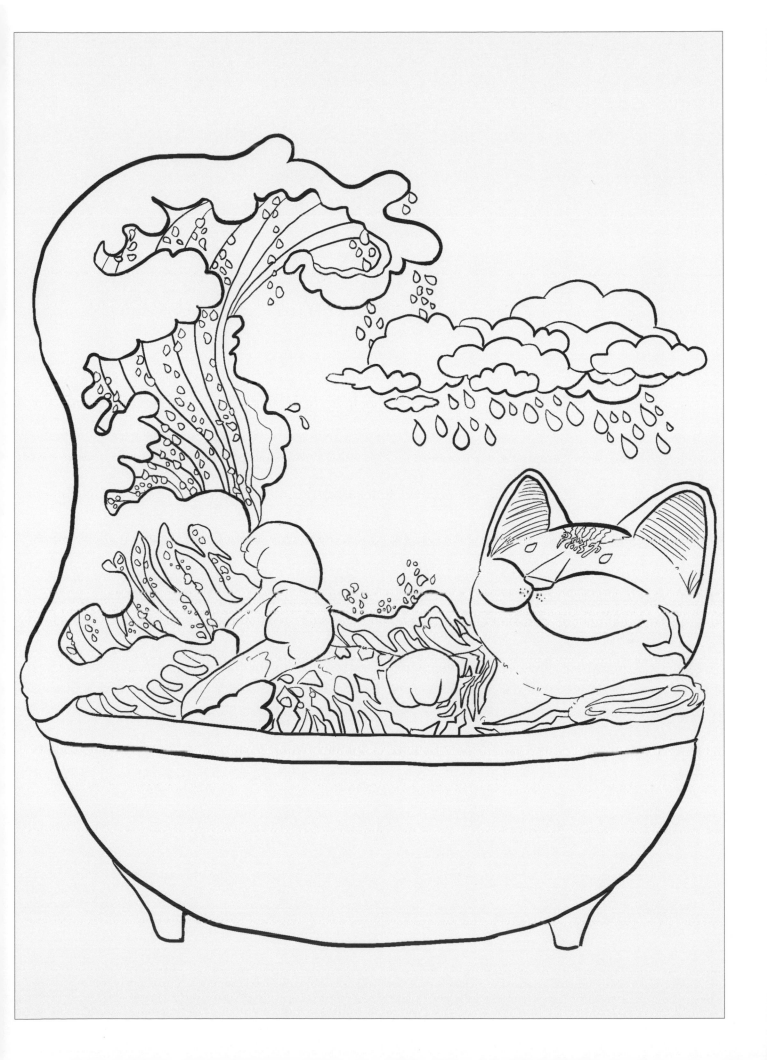

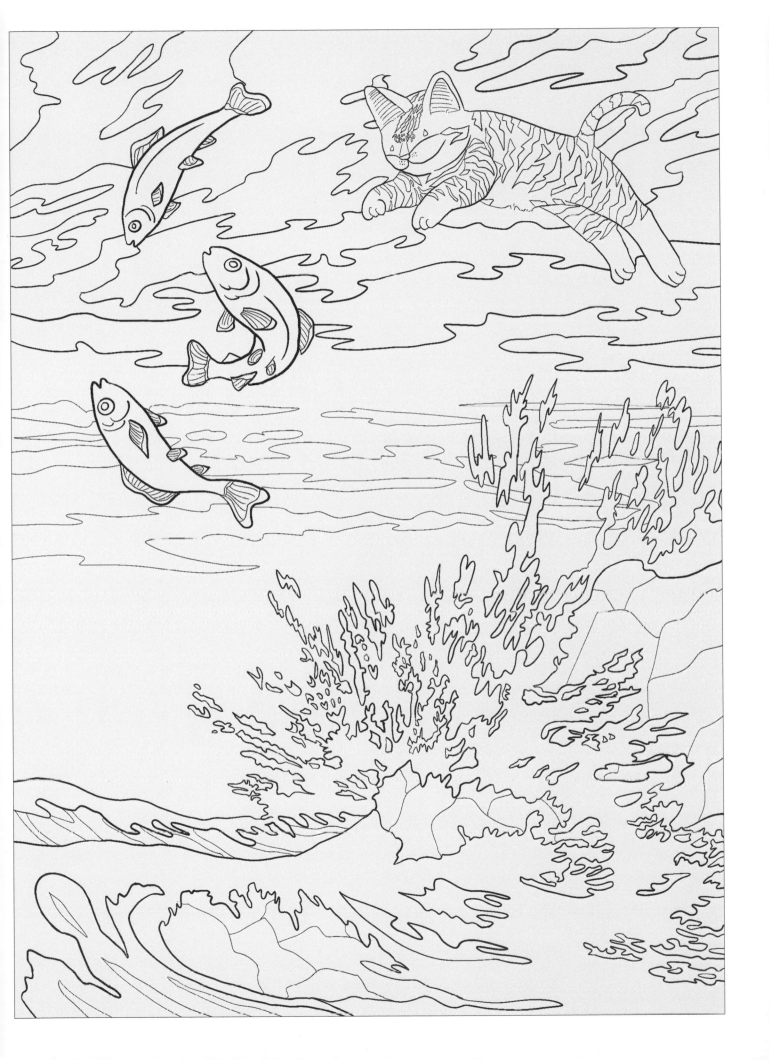

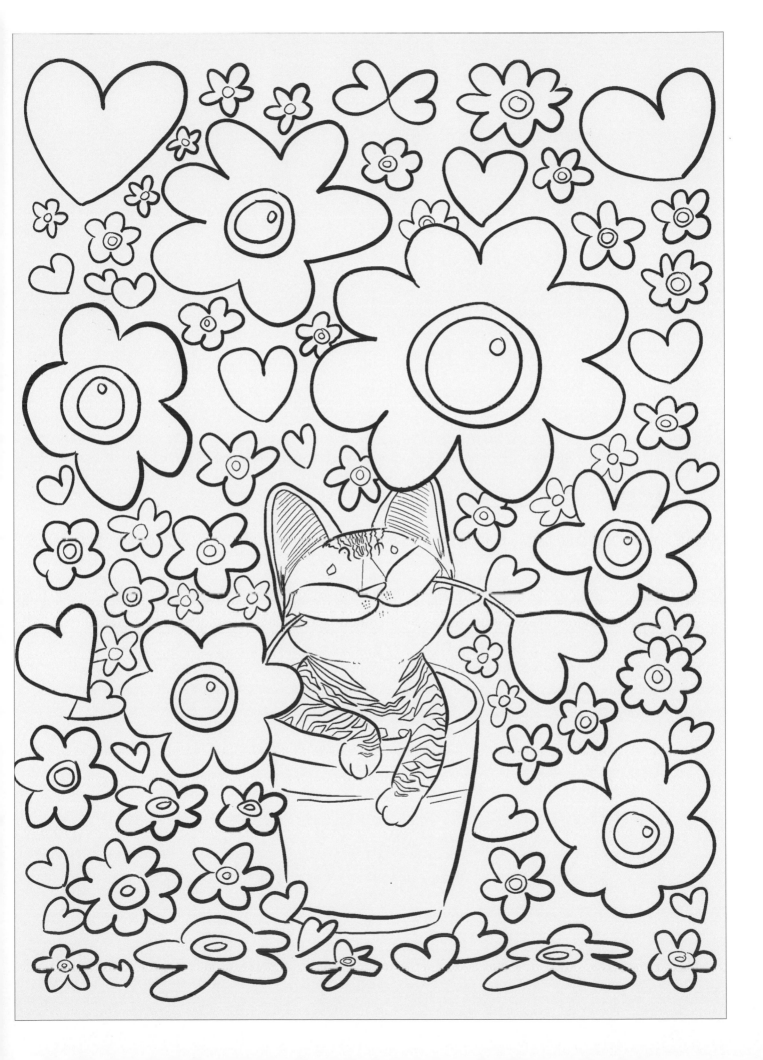

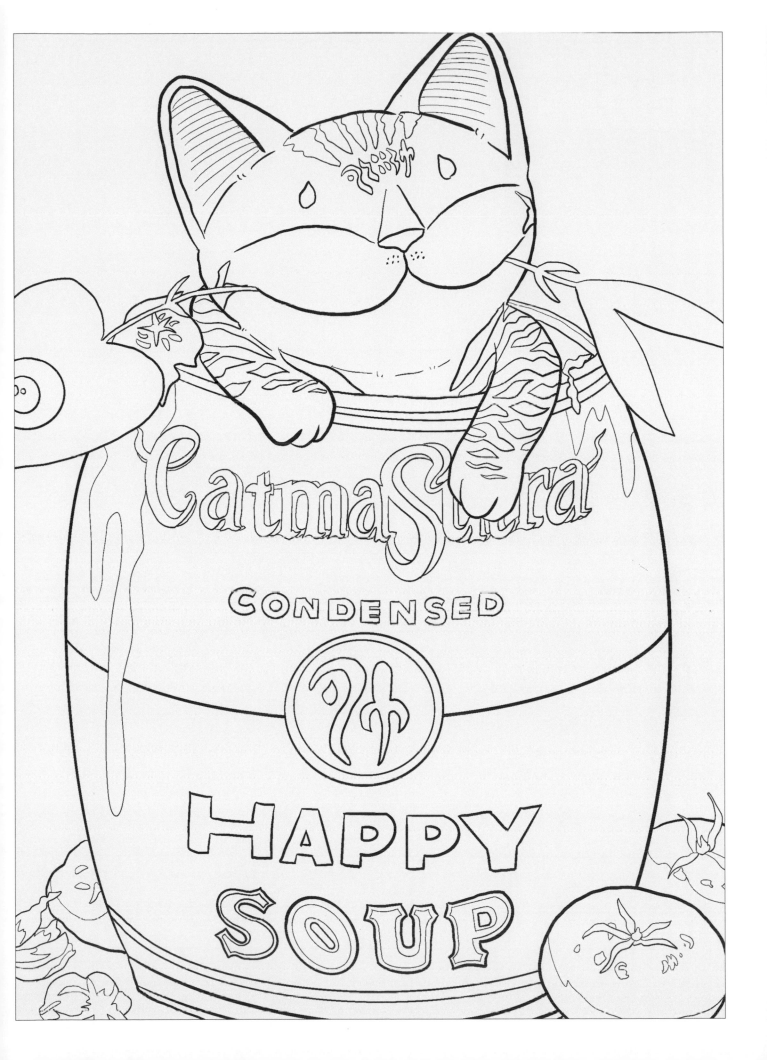

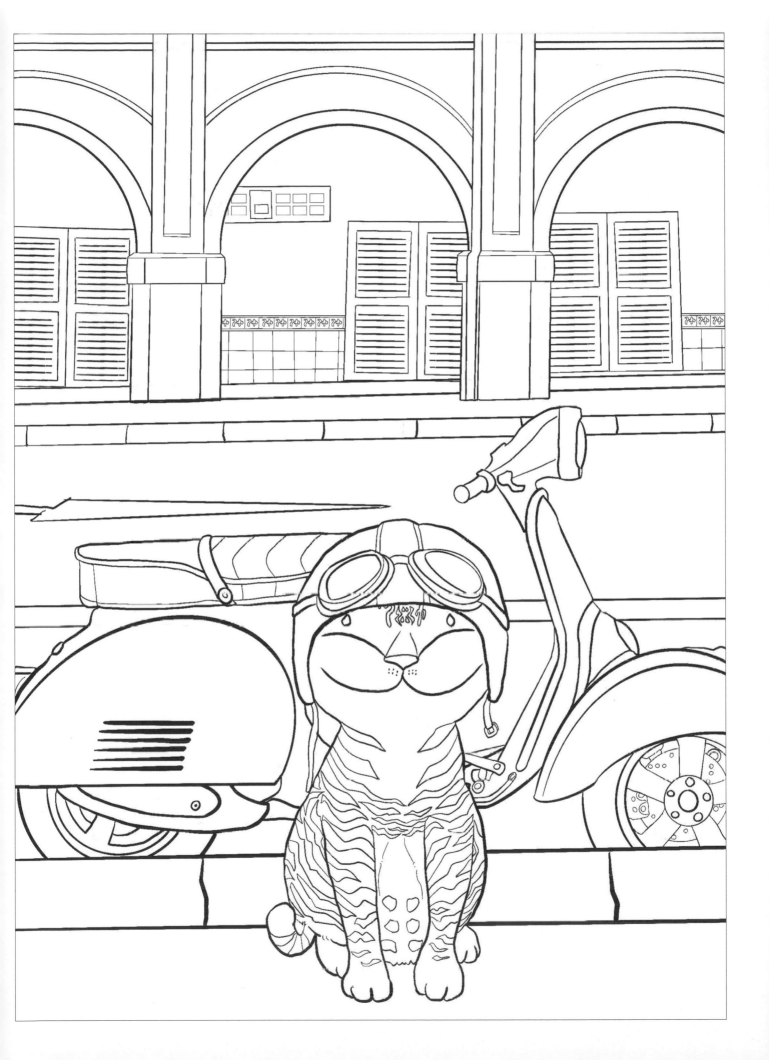

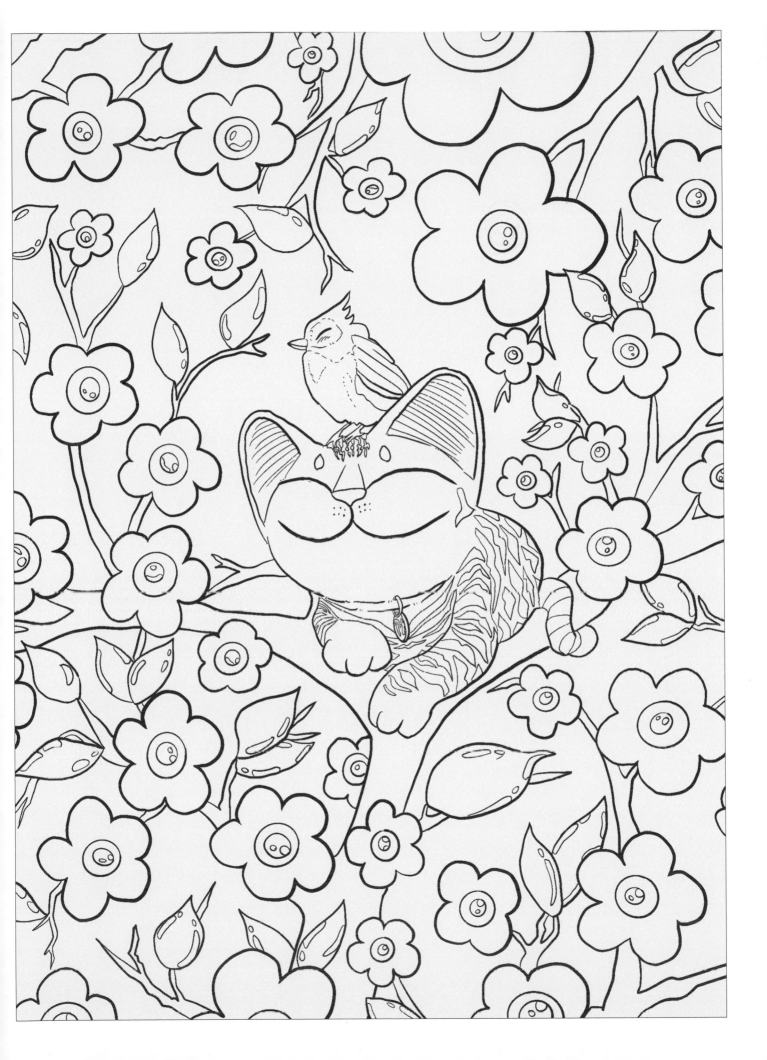

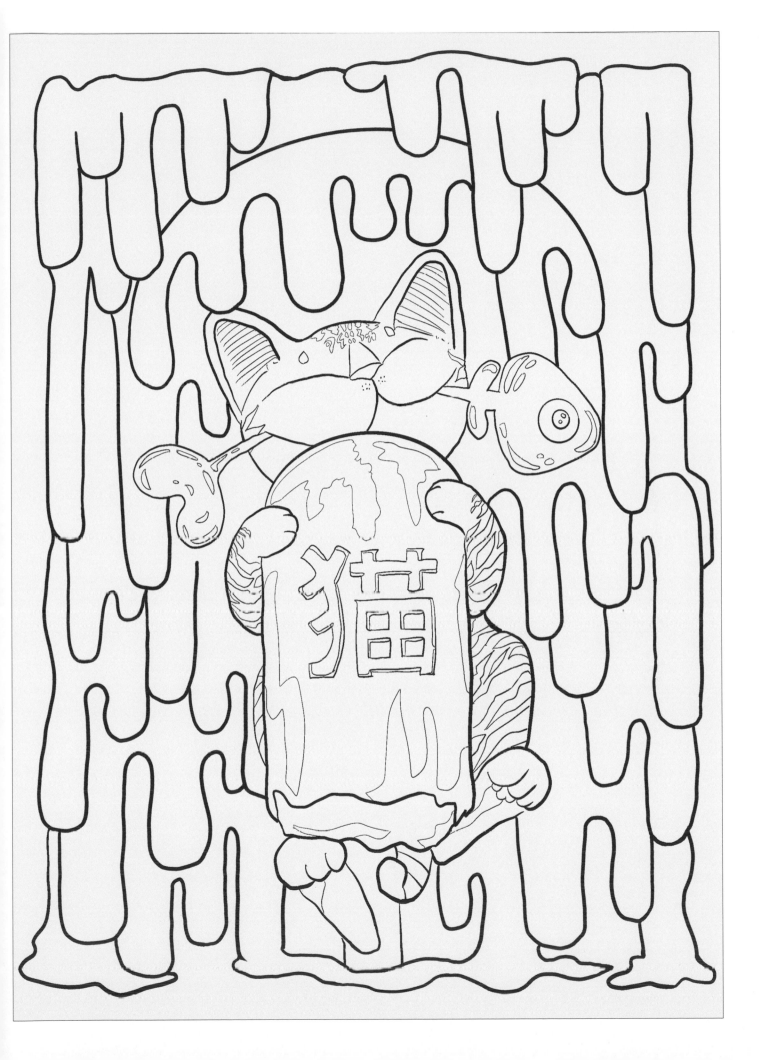

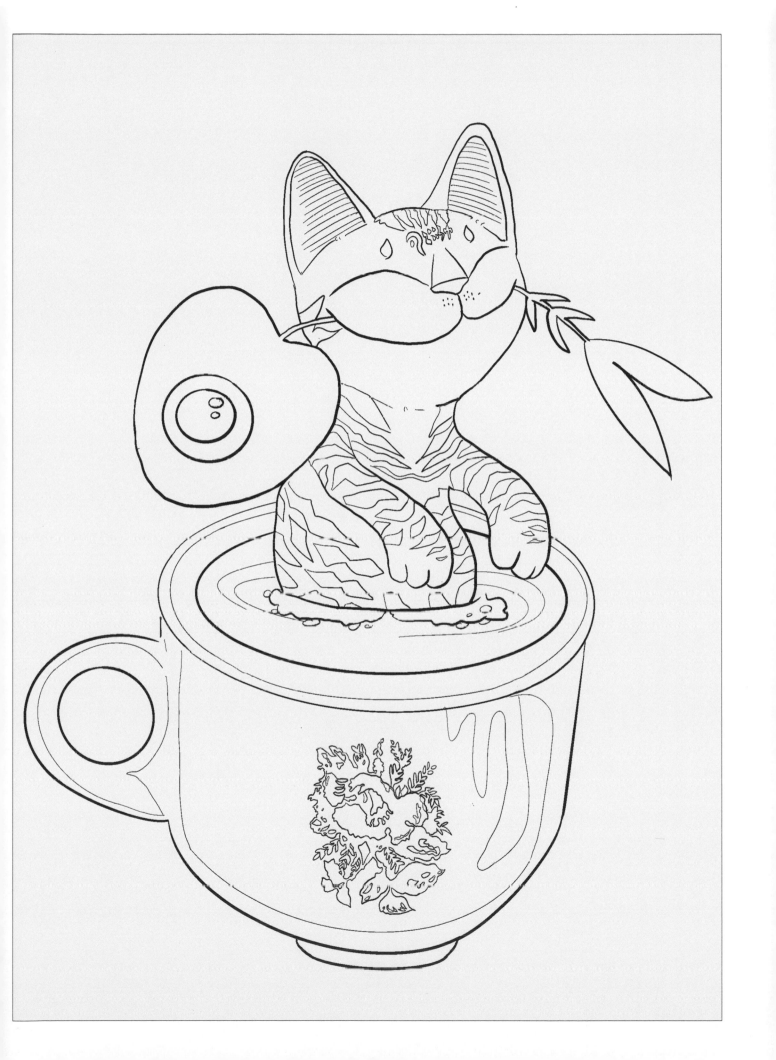

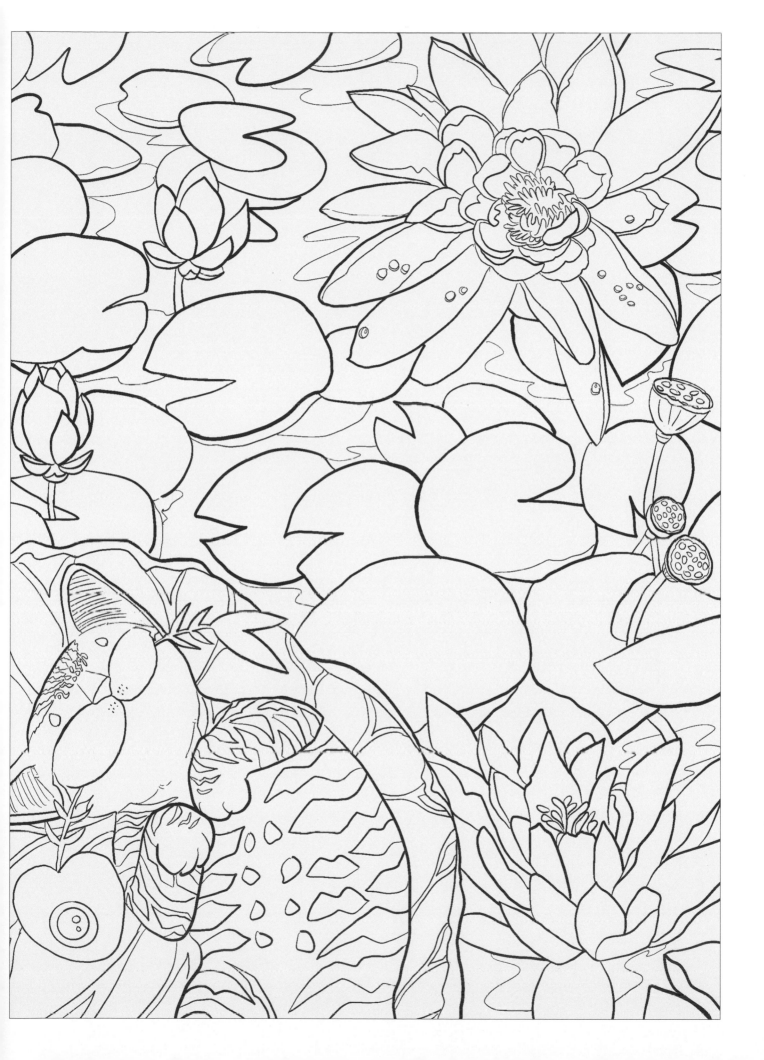

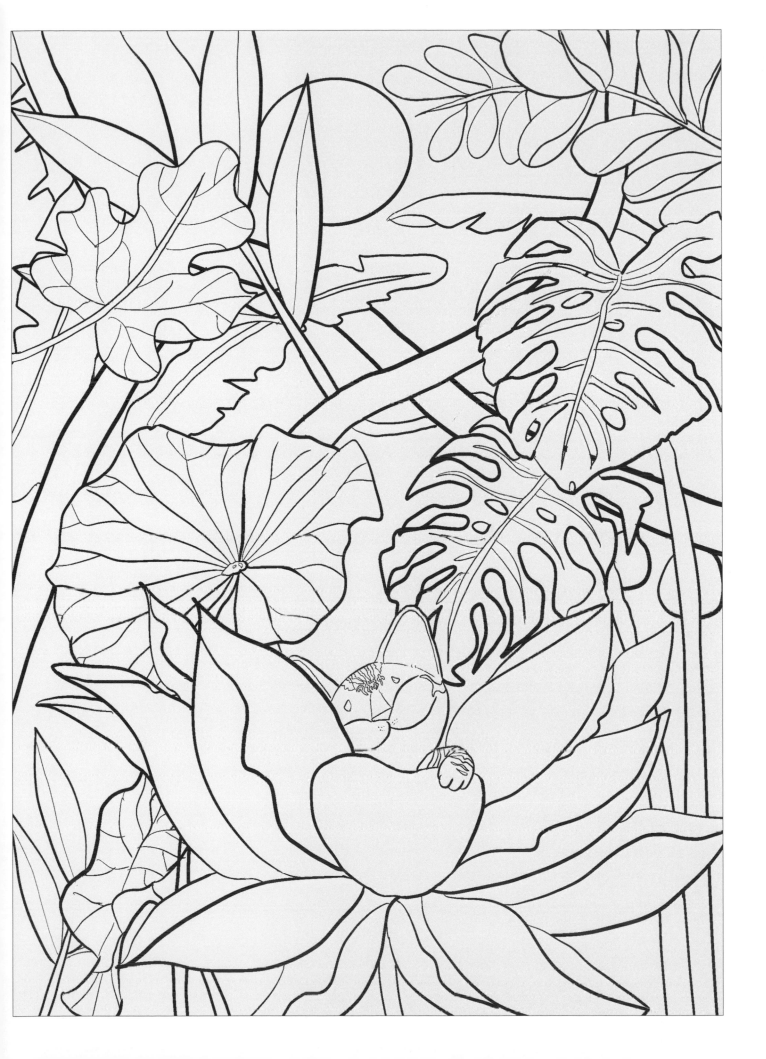

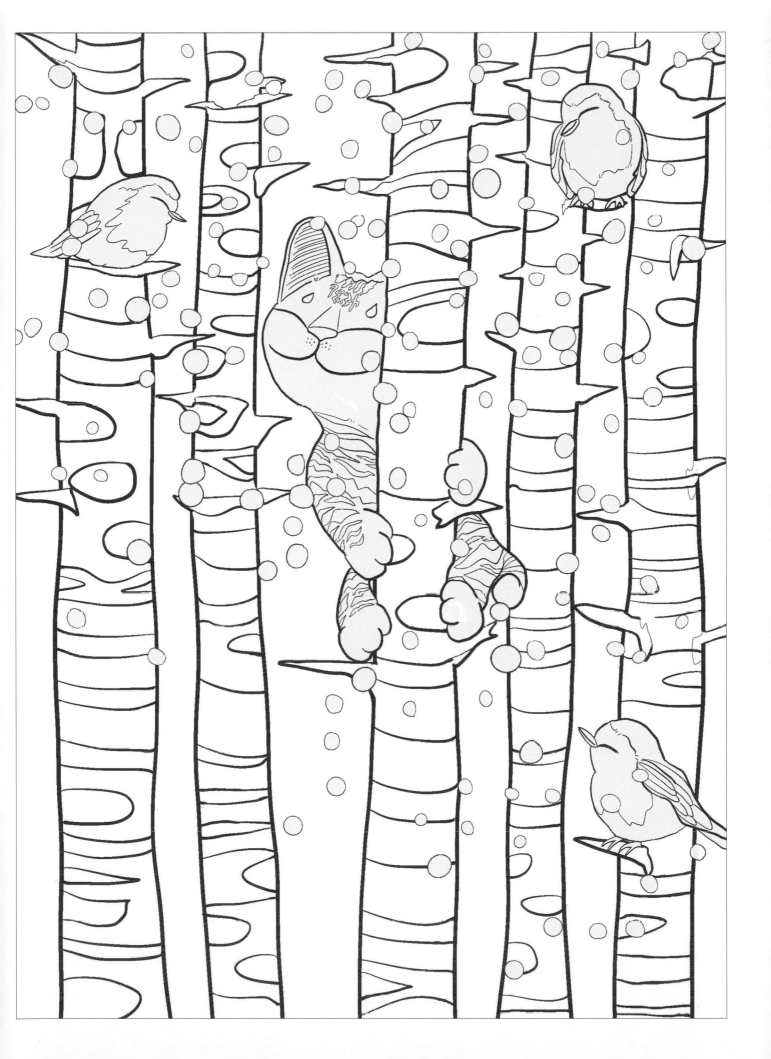

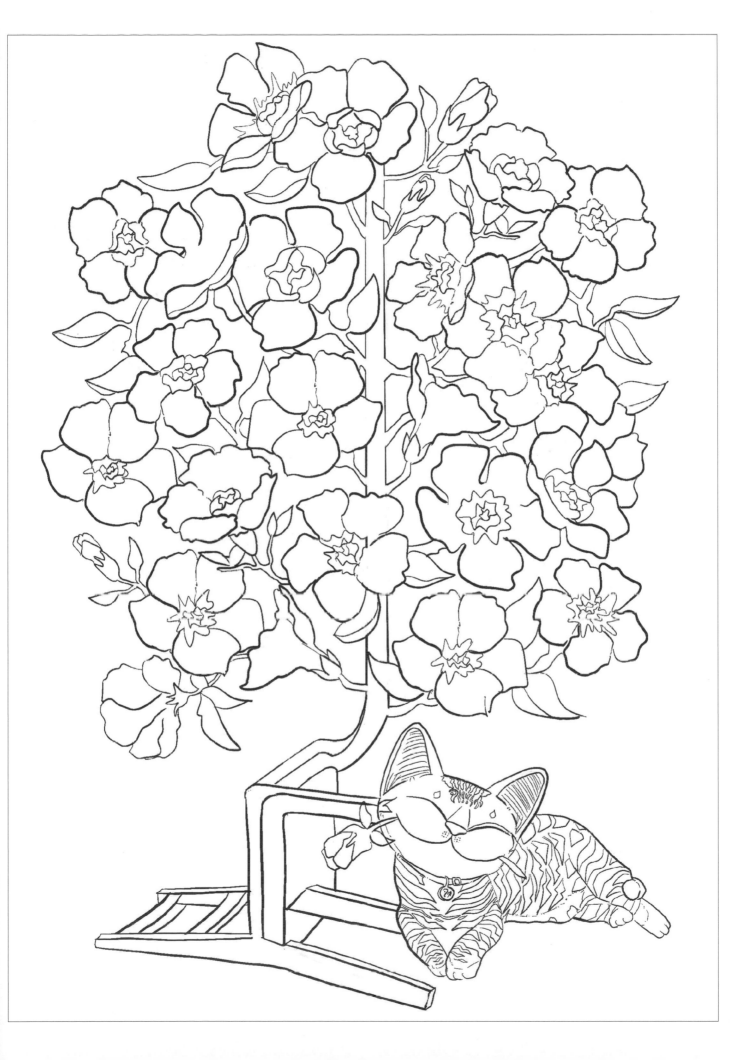

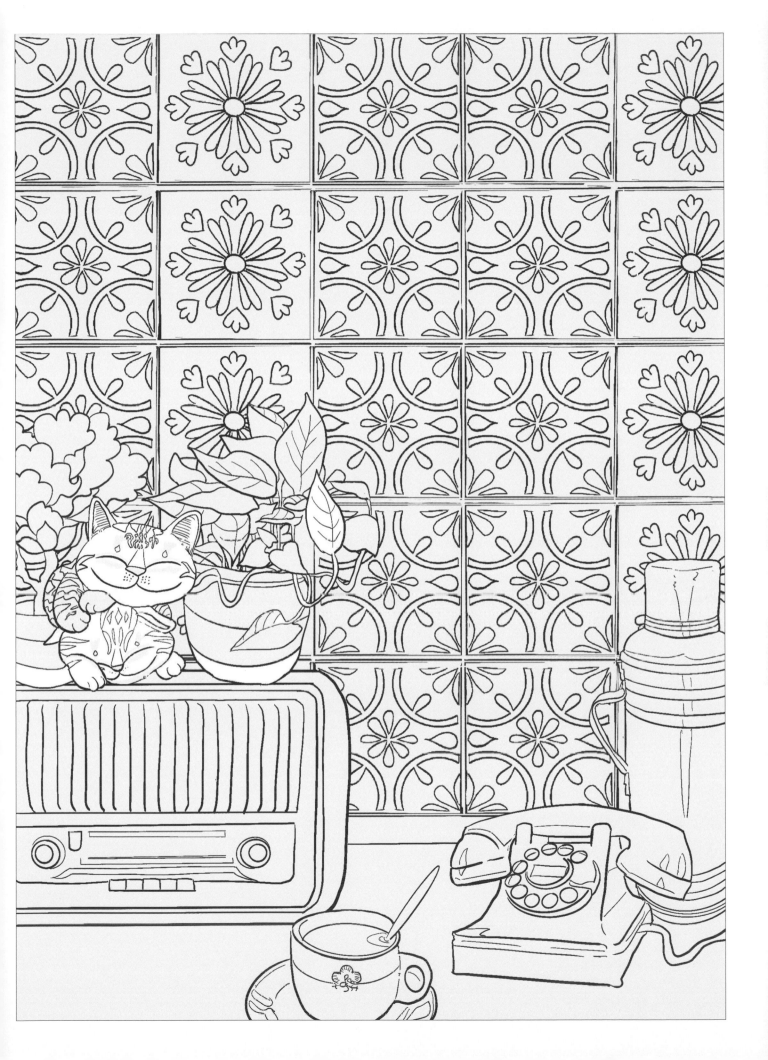

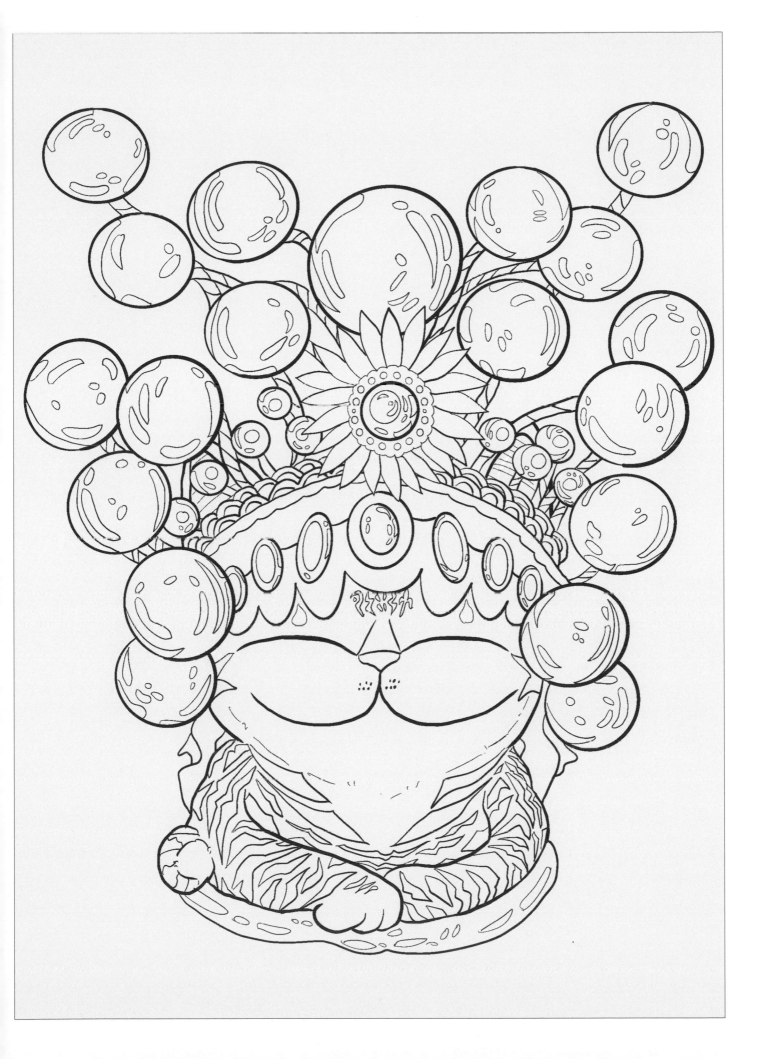

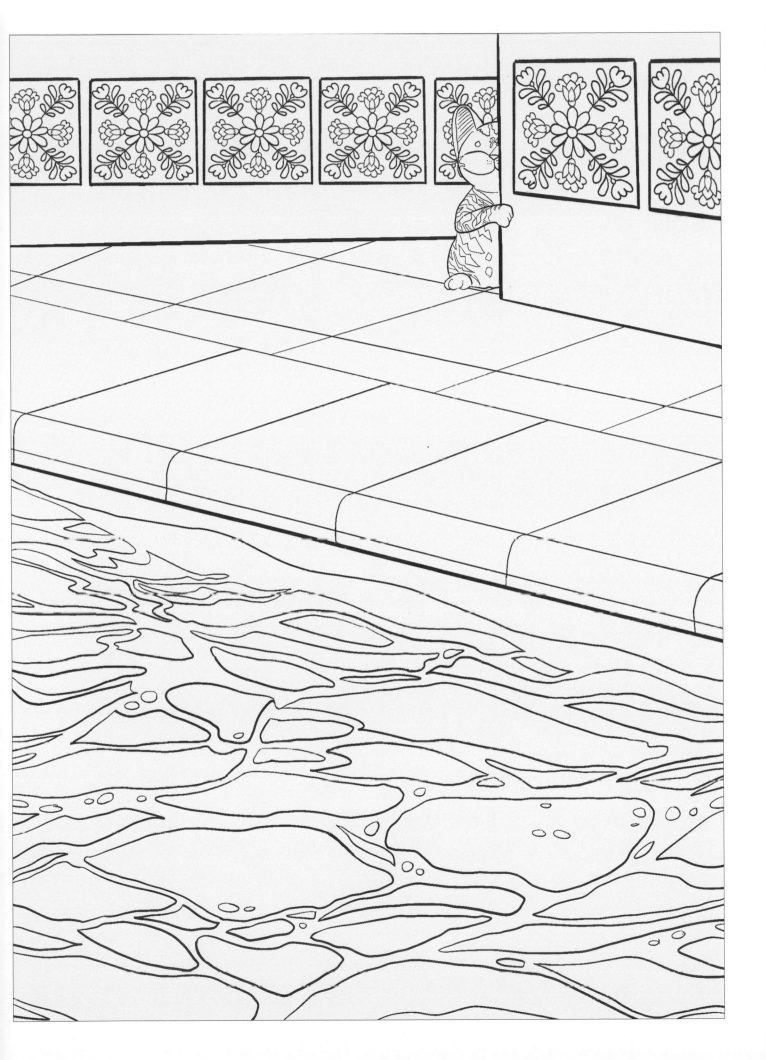

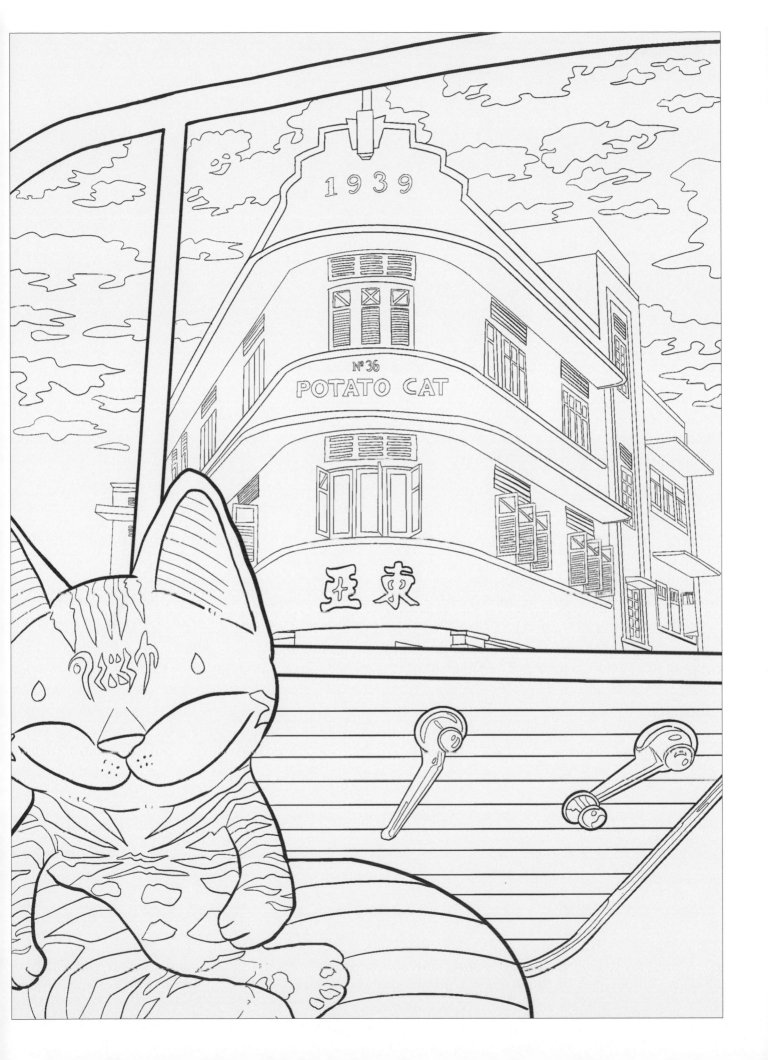

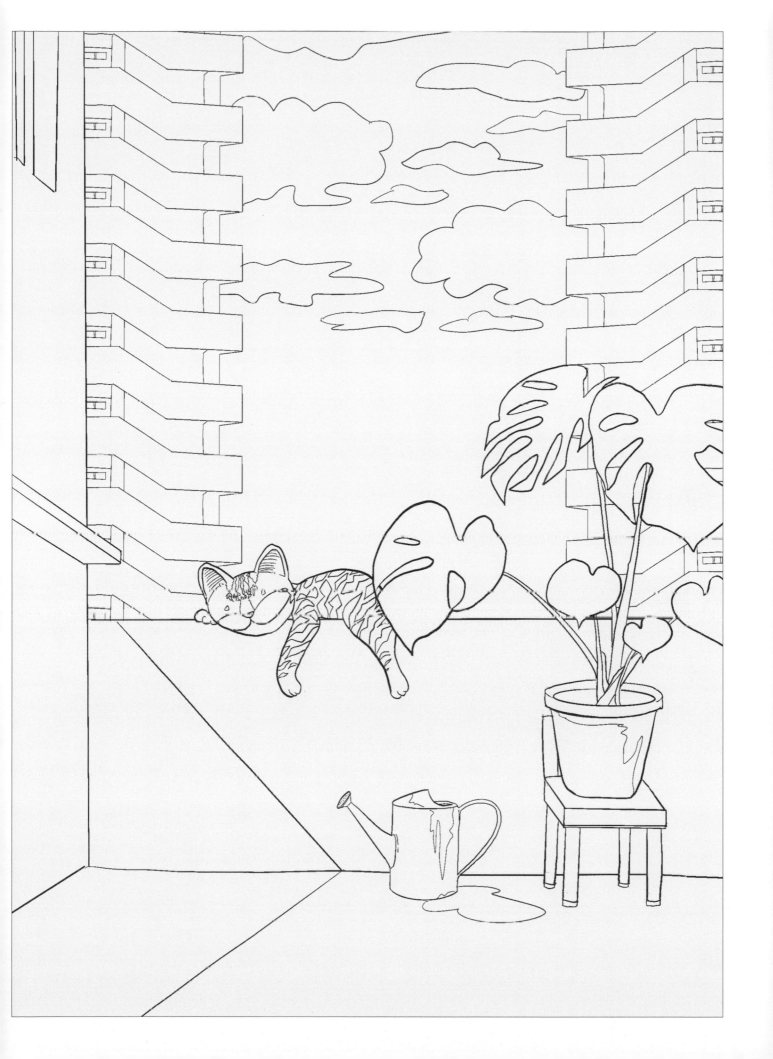

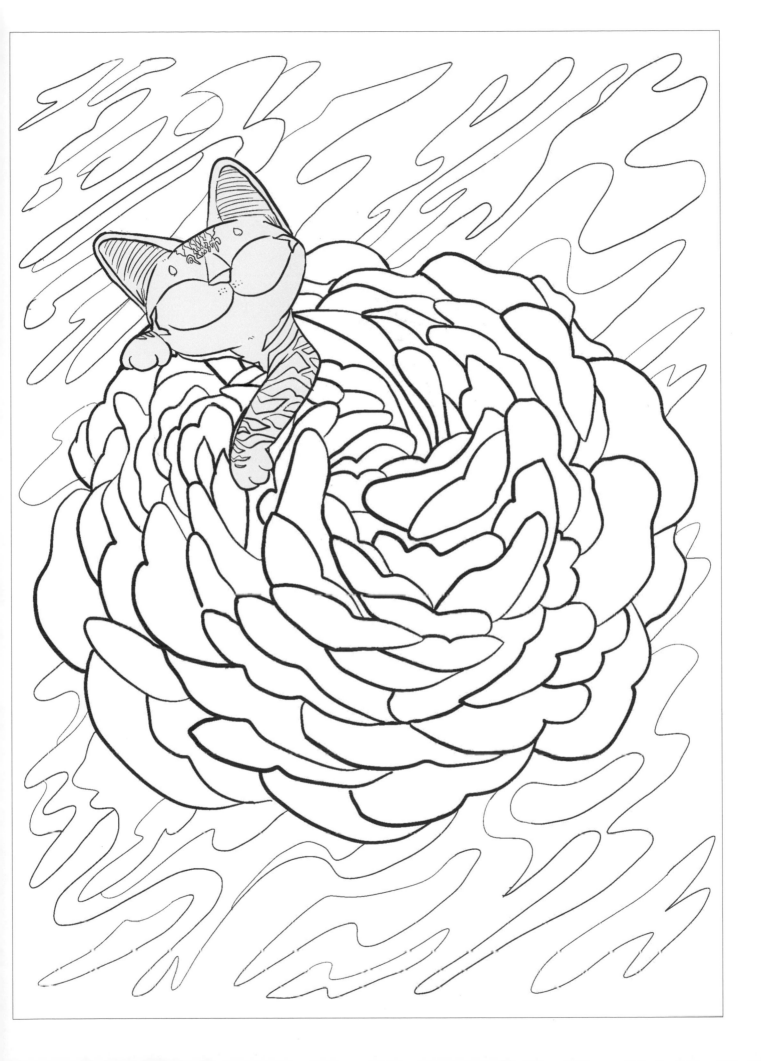

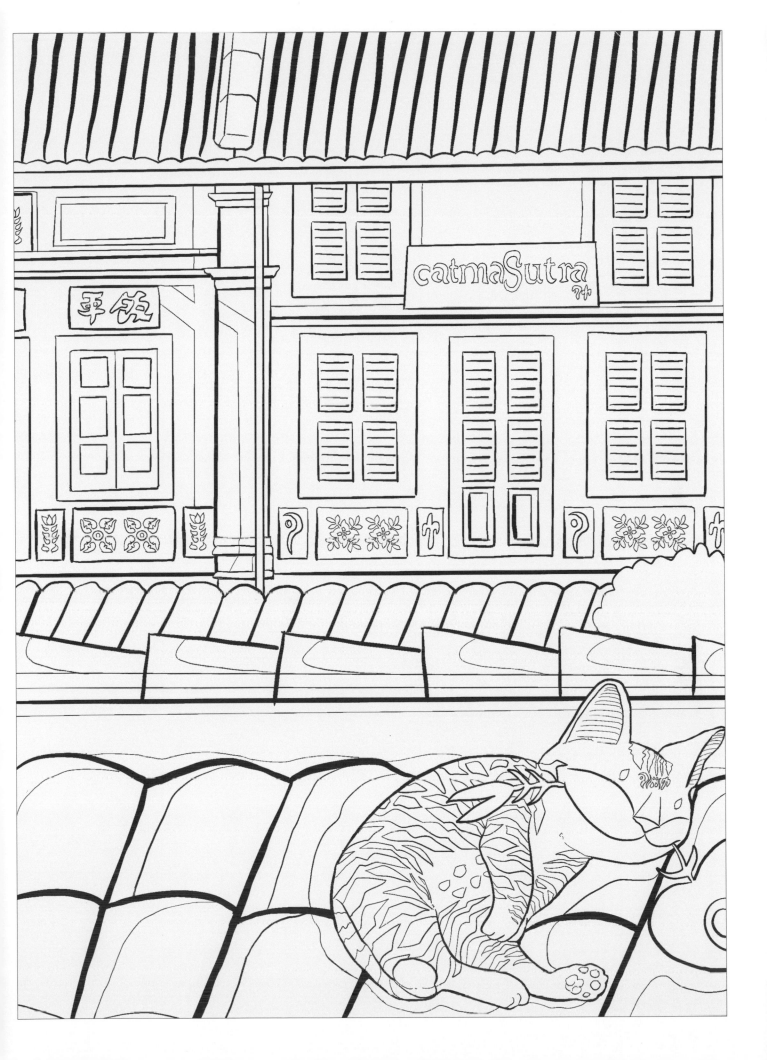

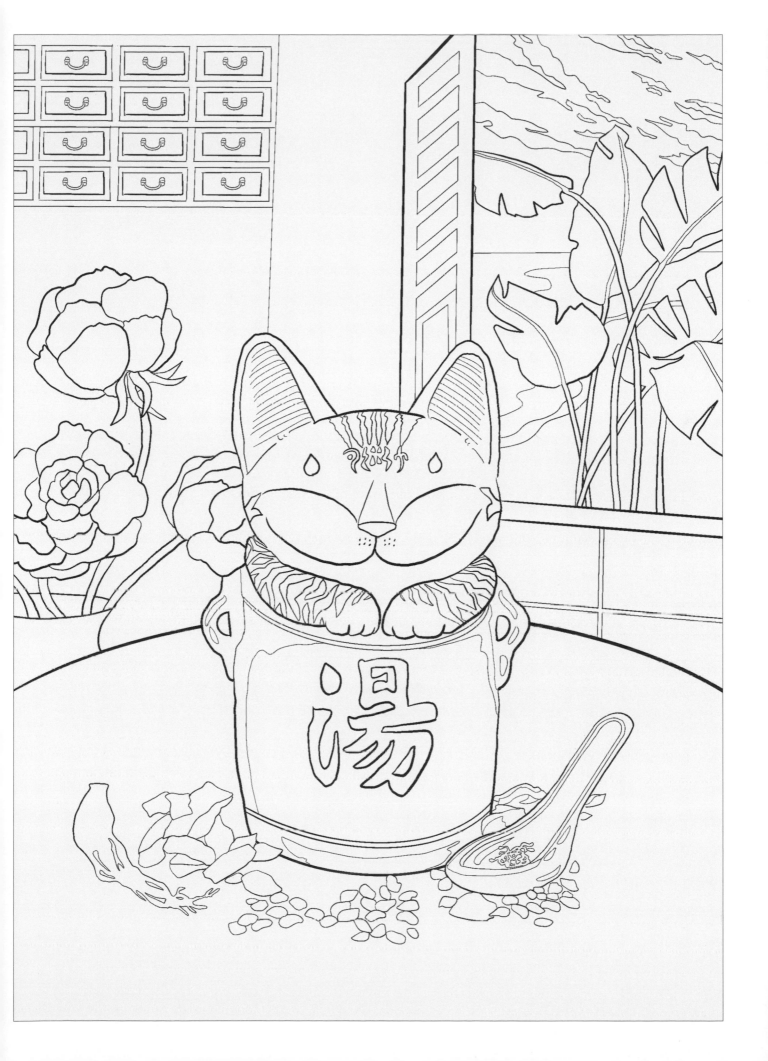

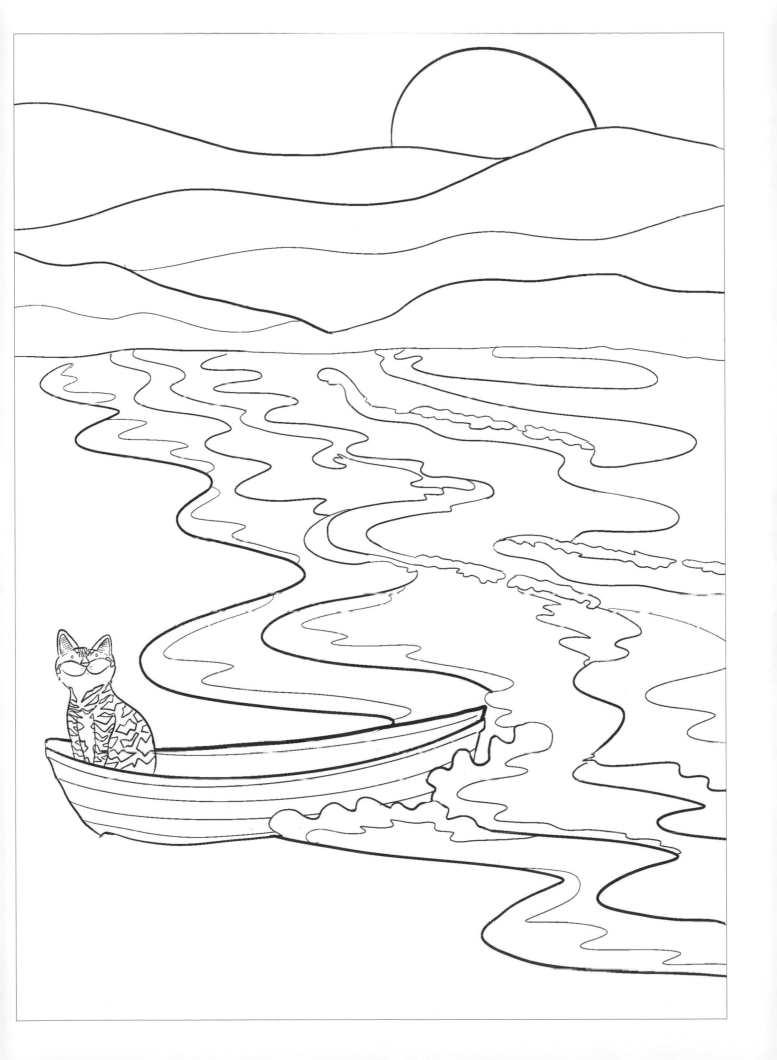

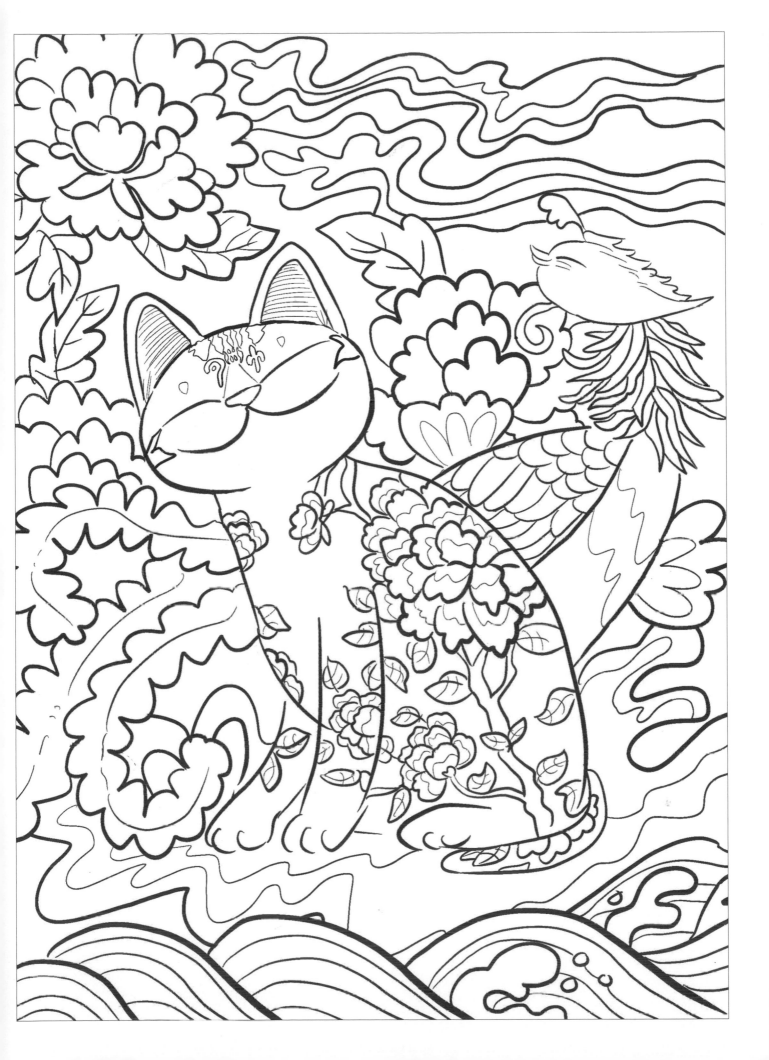

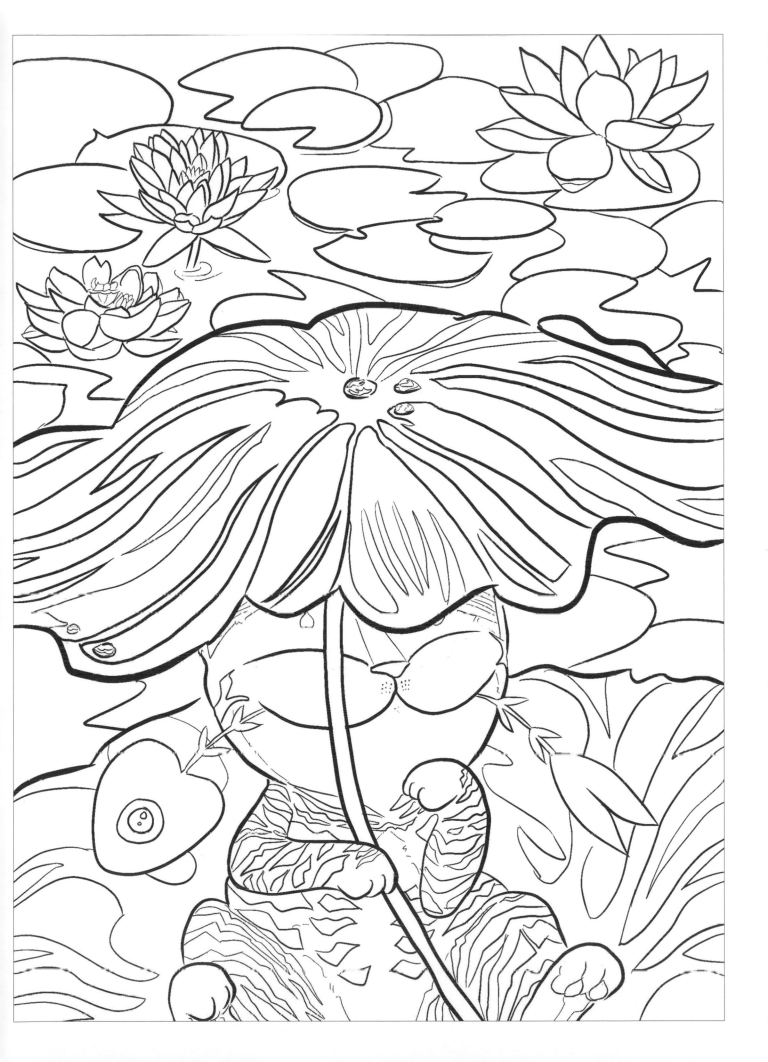

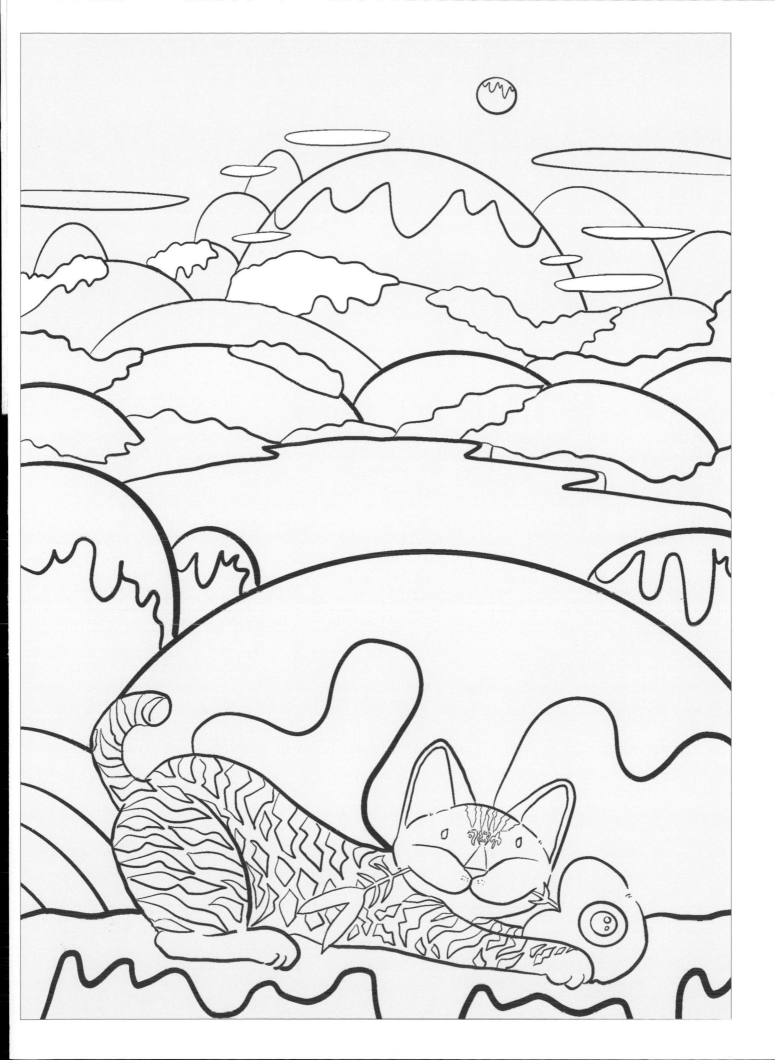

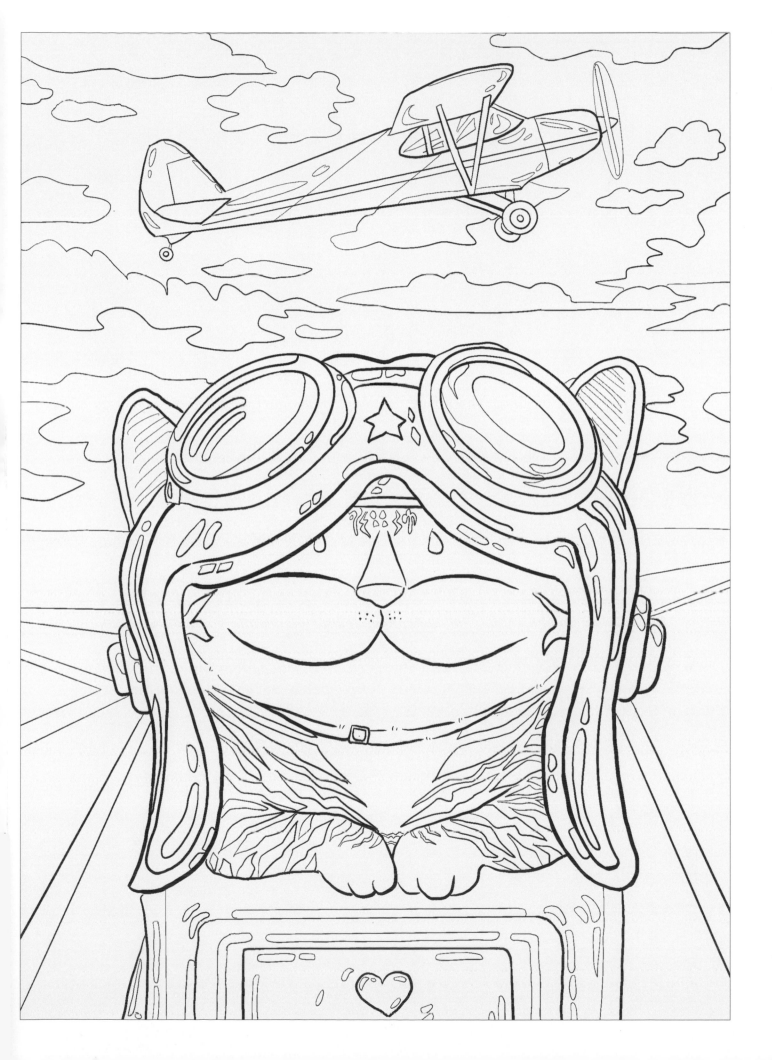

Published by Marshall Cavendish Editions
An imprint of Marshall Cavendish International

A member of the
Times Publishing Group

Other Marshall Cavendish Offices
Marshall Cavendish Corporation, 800 Westchester Ave, Suite N-641, Rye Brook, NY 10573, USA • Marshall Cavendish International (Thailand) Co Ltd, 253 Asoke, 16th Floor, Sukhumvit 21 Road, Klongtoey Nua, Wattana, Bangkok 10110, Thailand • Marshall Cavendish (Malaysia) Sdn Bhd, Times Subang, Lot 46, Subang Hi-Tech Industrial Park, Batu Tiga, 40000 Shah Alam, Selangor Darul Ehsan, Malaysia

Marshall Cavendish is a trademark of Times Publishing Limited.

ISBN: 978 981 5009 83 5

Printed in Singapore

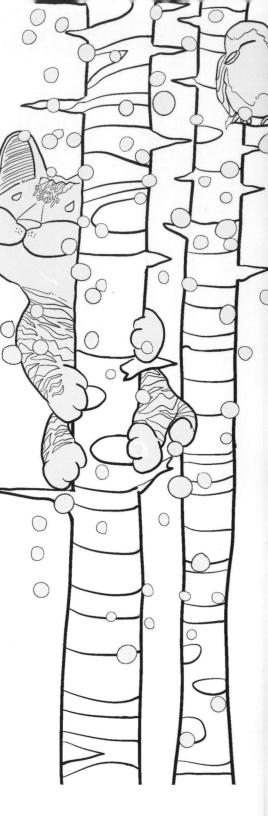